ARTISTS, Writers THINKERS, DREAMERS

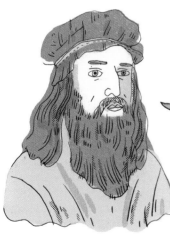

PORTRAITS OF
50 FAMOUS FOLKS
& ALL THEIR WEIRD STUFF
BY
JAMES GULLIVER HANCOCK

CHRONICLE BOOKS
SAN FRANCISCO

Every effort has been made to ensure the accuracy of all information included in this volume. Any errors that may have occurred are inadvertent and will be corrected in subsequent editions, provided notification is sent to the publisher.

Library of Congress Cataloging-in-Publication Data available.

ISBN: 978-1-4521-1456-9

Manufactured in China.

MIX
Paper from
responsible sources
FSC® C008047

10 9 8 7 6 5 4 3 2 1

Chronicle Books LLC
680 Second Street
San Francisco, CA 94107
www.chroniclebooks.com

CONTENTS

Abraham Lincoln.................... 8

Albert Einstein..................... 10

Alfred Hitchcock 12

Amelia Earhart 14

Andy Warhol 16

Babe Ruth 18

Barack Obama 20

Billie Holiday...................... 22

Bonnie & Clyde 24

Bruce Lee 26

Buzz Aldrin 28

Charlie Chaplin 30

Che Guevara 32

Cleopatra 34

Coco Chanel 36

Edith Piaf 38

Elvis Presley...................... 40

Ernest Hemingway 42

Frida Kahlo 44

Grace Kelly 46

Harry Houdini 48

Helen Keller 50

Howard Hughes 52

Jacques Cousteau 54

Joan of Arc 56

John Lennon....................... 58

Julia Child......................... 60

Leonardo da Vinci 62

Leo Tolstoy........................ 64

Louis Armstrong................... 66

Madonna 68

Mahatma Gandhi 70

Margaret Thatcher 72

Marie Curie 74

Marilyn Monroe 76

Martin Luther King Jr............. 78

Michael Jackson 80

Muhammad Ali 82

Napoleon Bonaparte 84

Oprah Winfrey..................... 86

Oscar Wilde 88

Princess Diana.................... 90

Queen Elizabeth I................. 92

Salvador Dalí...................... 94

Sigmund Freud 96

Thomas Edison 98

Vincent van Gogh................. 100

Winston Churchill................. 102

Wolfgang Amadeus Mozart................. 104

The Wright Brothers............. 106

INTRODUCTION

THE HUMAN RACE IS SURROUNDED BY STUFF

I love visiting a new friend's house and discovering that he collects antique squeezeboxes, or that the bracelet she wears is made from her great aunt's hair. It's beautiful that we are like little planets pulling detritus into orbit around us. We all know it's hard to get rid of things from our lives, and hoarding looms just around the corner. But there are some items you would never think to part with; they are linked to us through events in our lives or they just fit perfectly.

People seem to relax when they are around their things. It is how they define themselves and make their living situation "home." These things are extensions of us, props that we gather to help project an identity and help us interact with the world. We can learn a lot about a person from looking at what they choose to surround themselves with. In his book *Blink*, Malcolm Gladwell notes that students are far more successful at assessing someone's personality from a glance at their dorm room possessions than spending time with the actual person.

I have always been intrigued by people's relationship to objects. Having traveled extensively, I've witnessed the waxing and waning of my possessions with different locations. There are things that have stuck with me out of necessity and things that I hold on to for no reason other than I like having them around. I love both the feeling of freedom that carrying only a suitcase can bring and the strong sense of security that keeping a collection of personal trinkets provides. Sometimes stuff feels like a burden and other times it seems to connect us more strongly to our world. I've become hyper-aware that I hold onto certain things, that they are mine, and that they are important. My father worked in estates of the deceased and the collections of each life's worth of "stuff" was always a fascinating summary of that person.

Like possessions, small quirks reflect a person's identity; their clothes, their favorite food, the house they grew up in, the people they know. I'm a visual communicator and I always found it interesting that people have these props that become extensions of who they are. When I think of Che Guevara I think of his beret;

when I think of Grace Kelly I think of that classic scarf; when I think of Elvis I think of that super sandwich. They are physical objects that provide visual clues about who a person is or has decided to be. They may seem to be on the surface, decoration on the façade, but the fact that these particular bits and pieces become easily associated with and connected to these particular people says something about who they are.

This project started when I was living in New York. I was drawing buildings for my blog allthebuildingsinnewyork. com and started to think about the people who were inside those buildings. As a newcomer to the city from Australia, I was amazed at how many characters you would see walk by on a daily basis and I would wonder which building was theirs. Everyone seemed to have their own style or quirk. Who are they? What stuff do they use? How do they get around? What do they eat? What are their routines? What makes each one different from the next person on the street? It was these potentially infinite characters with their infinite quirks that I loved and wanted to explore. Initially not having too many friends in New York I started to make them up, to invent characters and draw them: office workers who loved bees, tugboat drivers who collected toy trains and caught the A train to work. Somehow it helped me organize the chaos of a huge society of individuals.

Over time I started applying this style of drawing to people I knew and capturing their visual summaries (you can see mine at the end of the book). And later I became intrigued by searching out these same kinds of objects and icons for the great figures of history. It's a voyeuristic attempt to delve deeper into people I have no primary access to, an obsessive sorting of the human experience.

The people in this book are all extraordinary in some way and have inspired me because of the lives they've lived. By reducing them to these basic equations of ordinary life it's fascinating to see how much their everyday choices make them more human. How some of their habits and rituals are within basic human need; what they like to eat, where they were born, even the stories of their unusual deaths or marriages can make them seem normal in this context. Obviously not everyone has a 10-carat engagement ring like Grace Kelly, but most people do love a slice of cheesecake now and then. Collecting people's detritus at once makes them extraordinary and human at the same time.

This book is a visual encyclopedia, allowing glimpses into iconic figures' personalities. These props and events tell a part of the story of who they are in a way that is sometimes clearer and more revealing than words. These are not meant to encompass their entire lifetime of achievements but they do reflect the one solid identity of each person built up over years of their life. They are refined here to their favorite things, shuffling around them, and we are left wondering why the universe gave those particular things to them.

So I invite you to explore these people in this visual summary. I guarantee you will learn something about people you thought you knew, and hopefully gain an insight into the quirky nature of the human experience.

JAMES GULLIVER HANCOCK

ABRAHAM LINCOLN

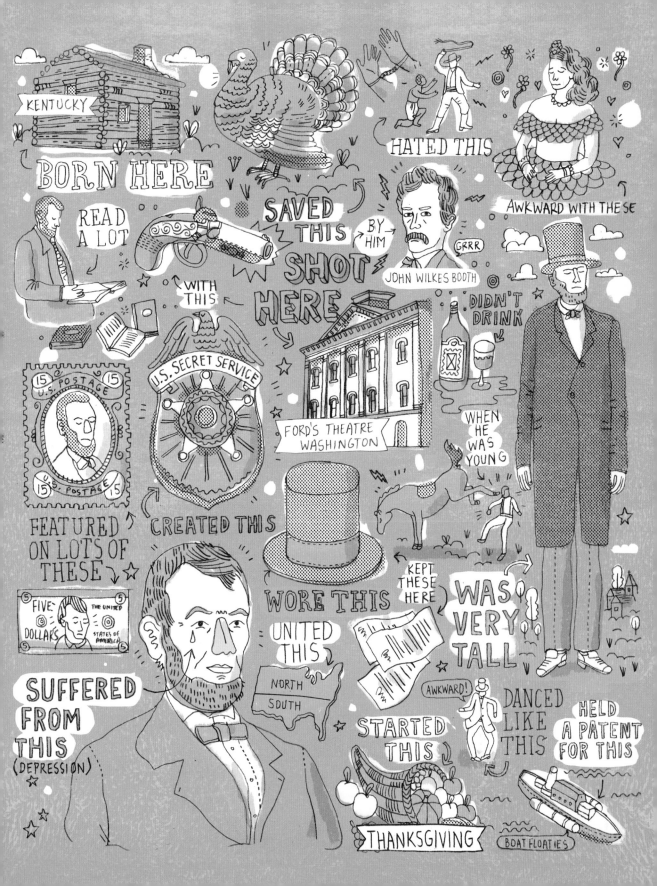

ALBERT EINSTEIN

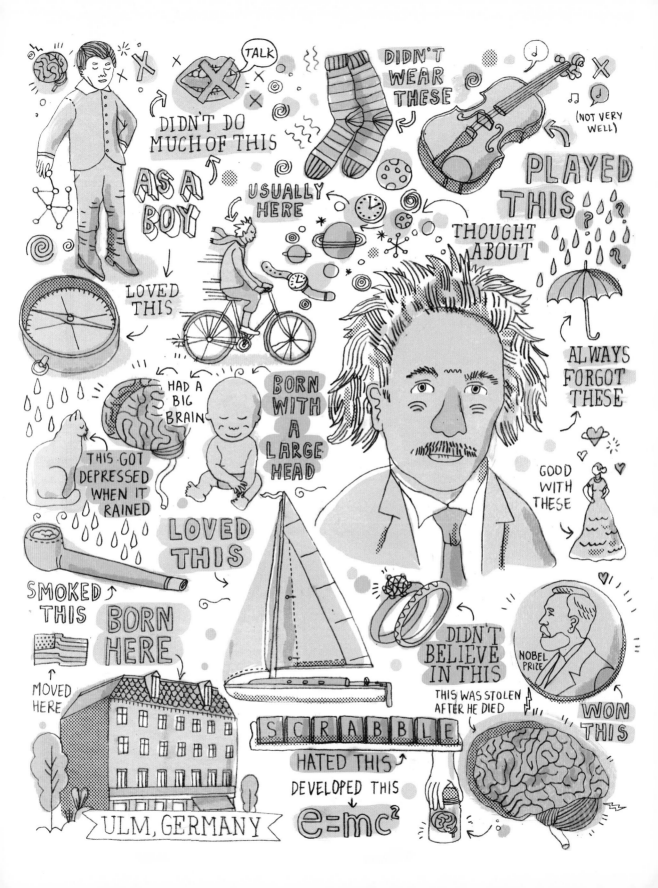

ALFRED HITCHCOCK

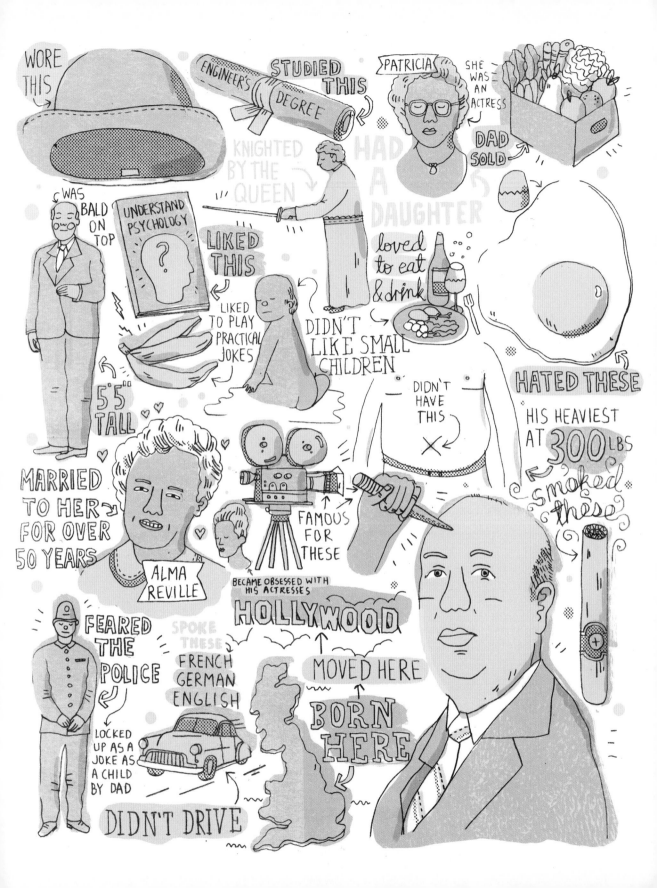

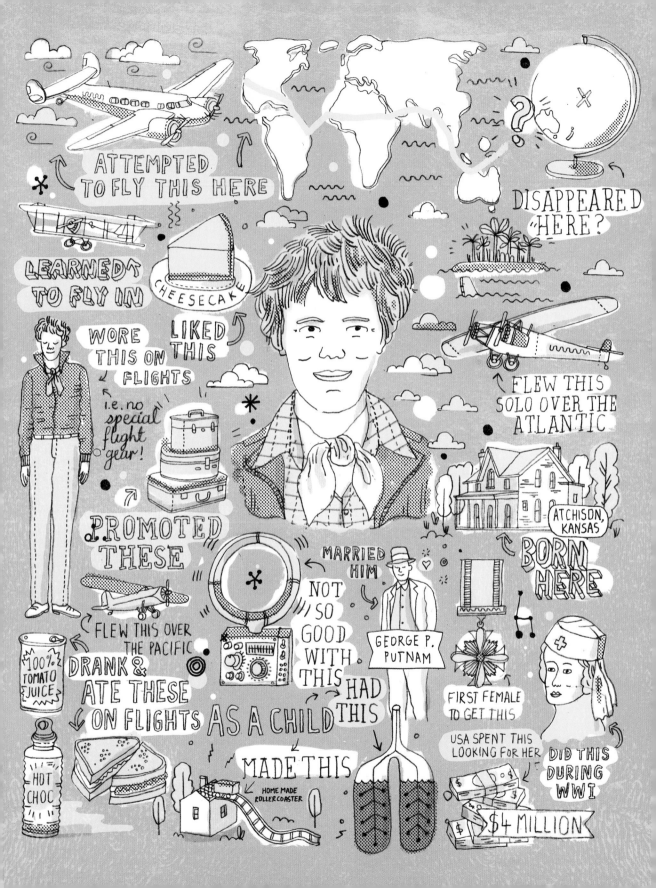

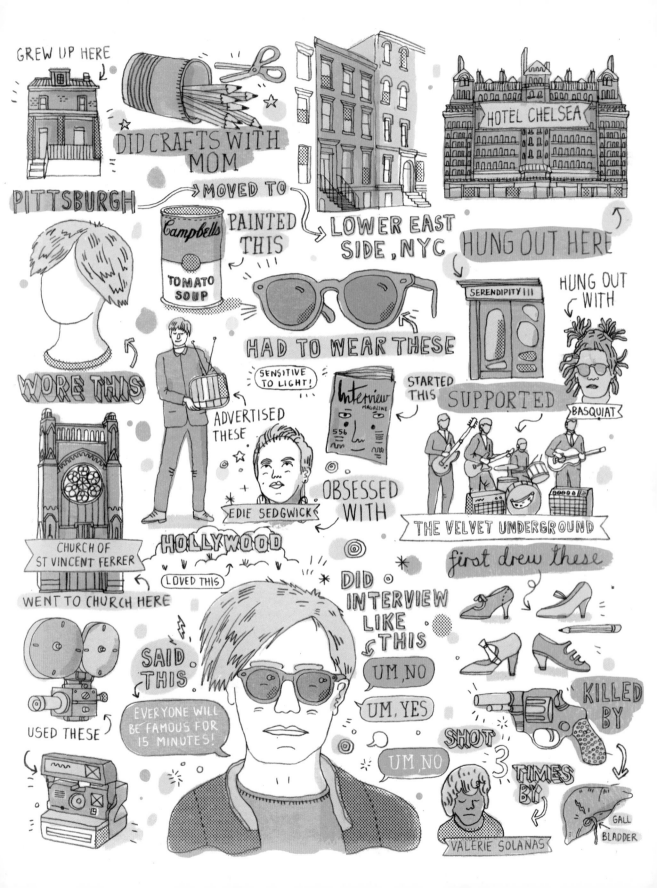

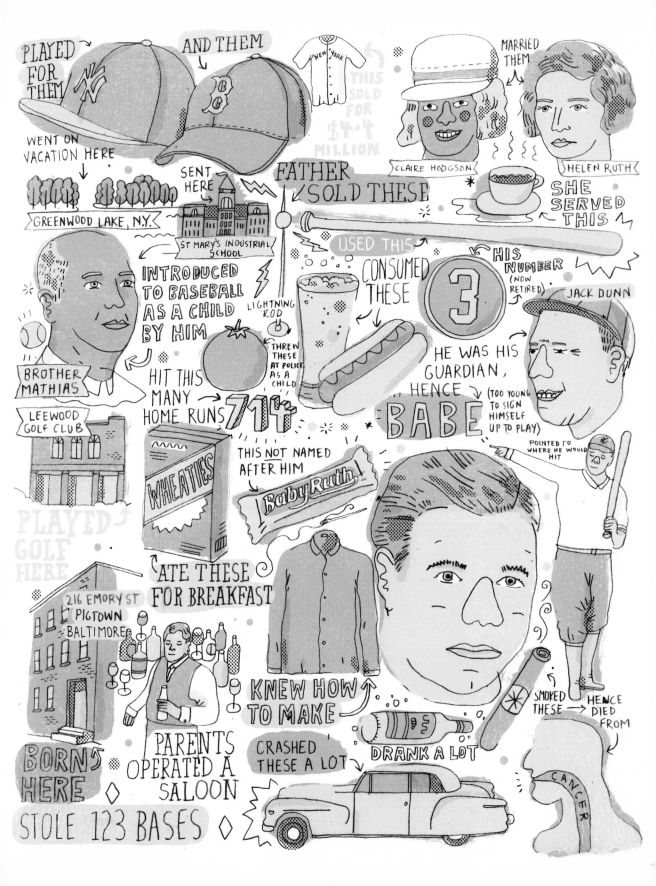

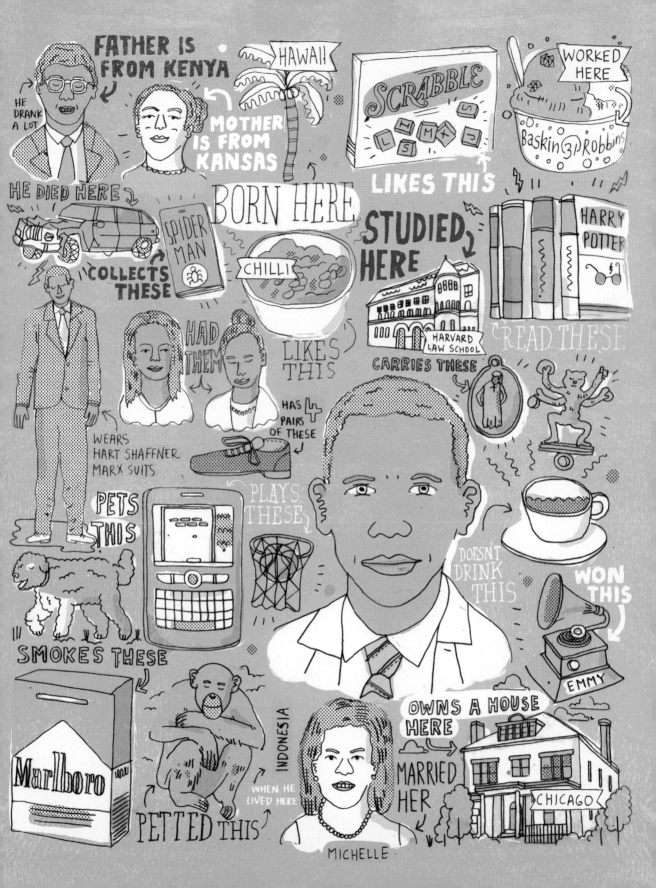

BILLIE
HOLIDAY

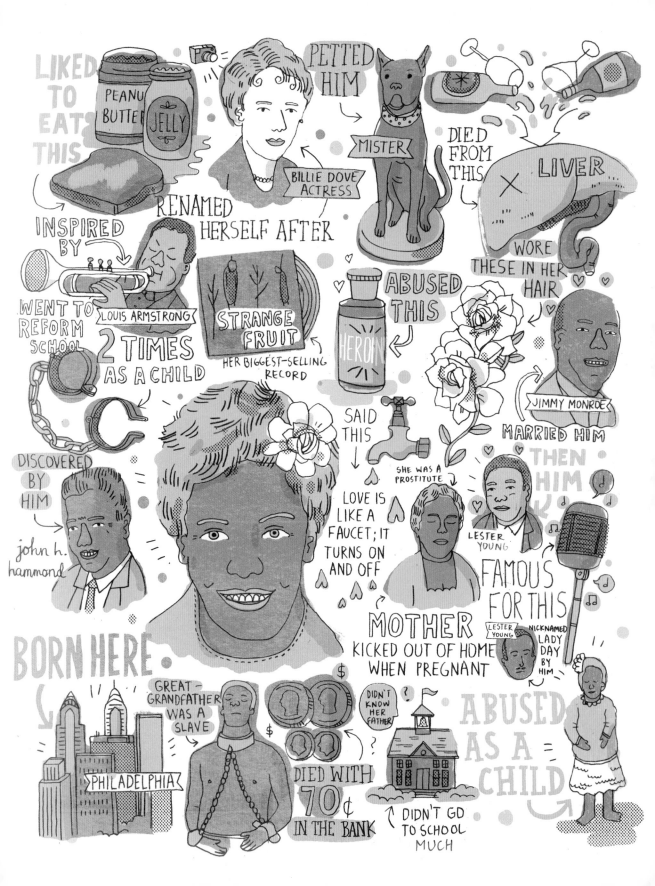

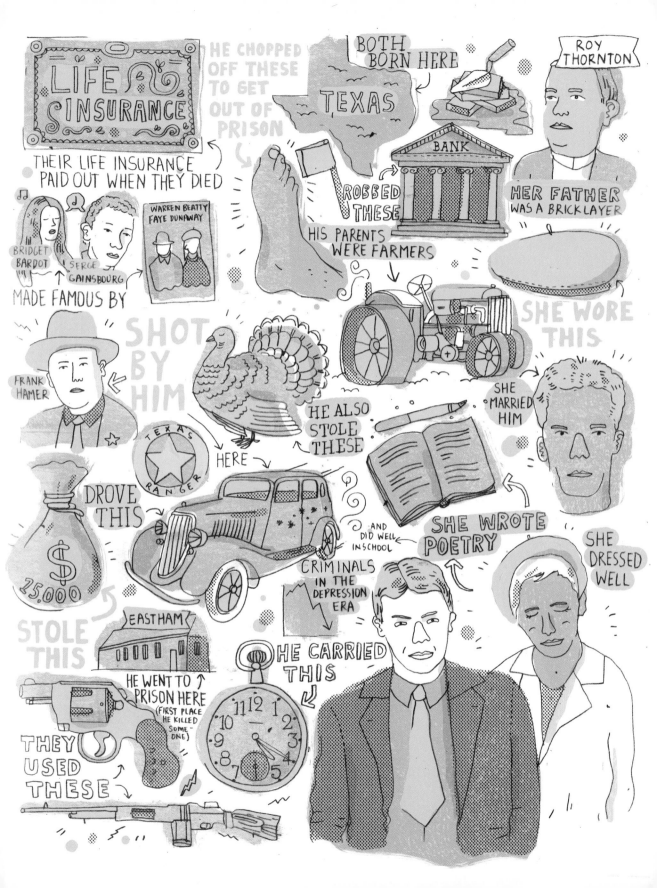

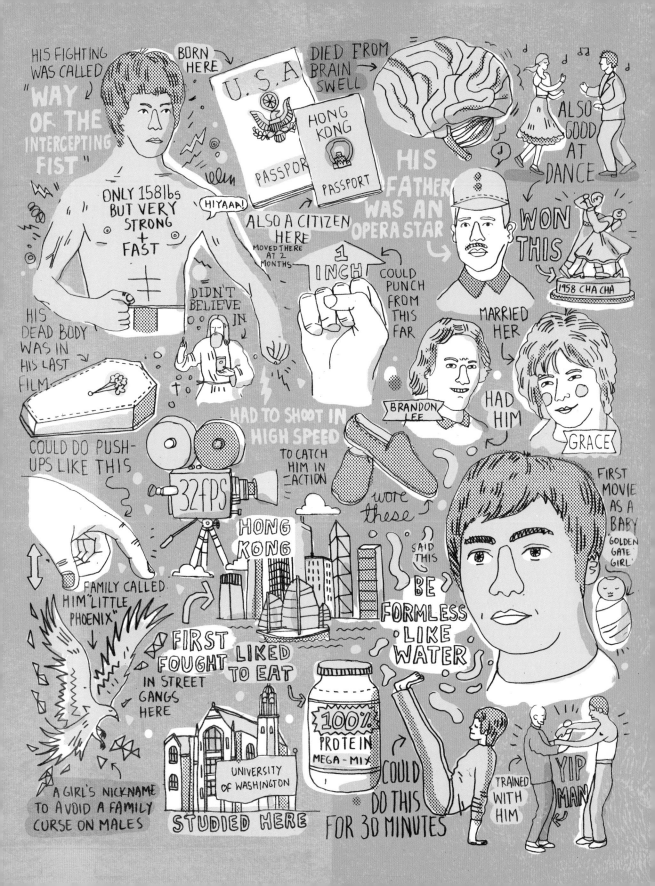

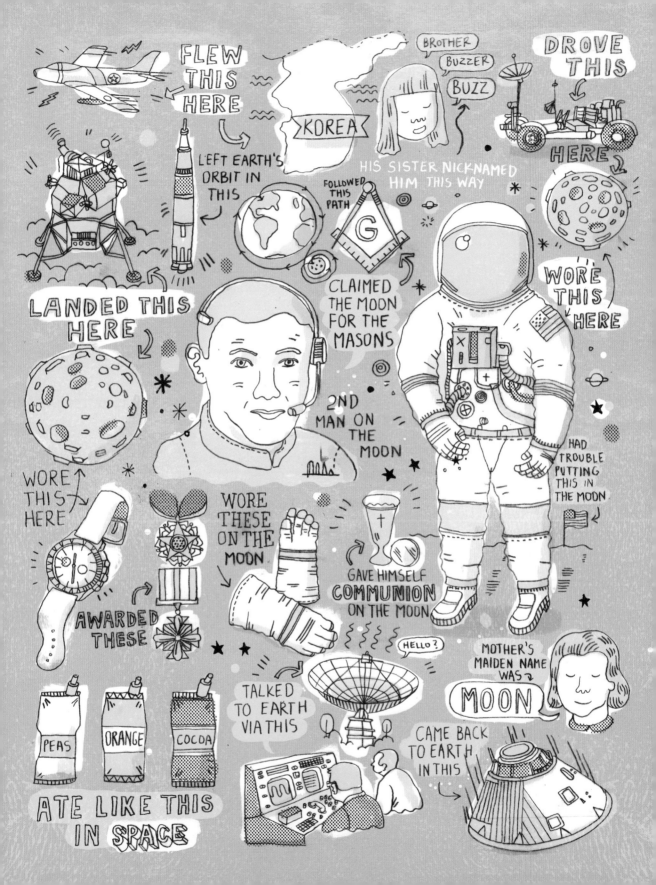

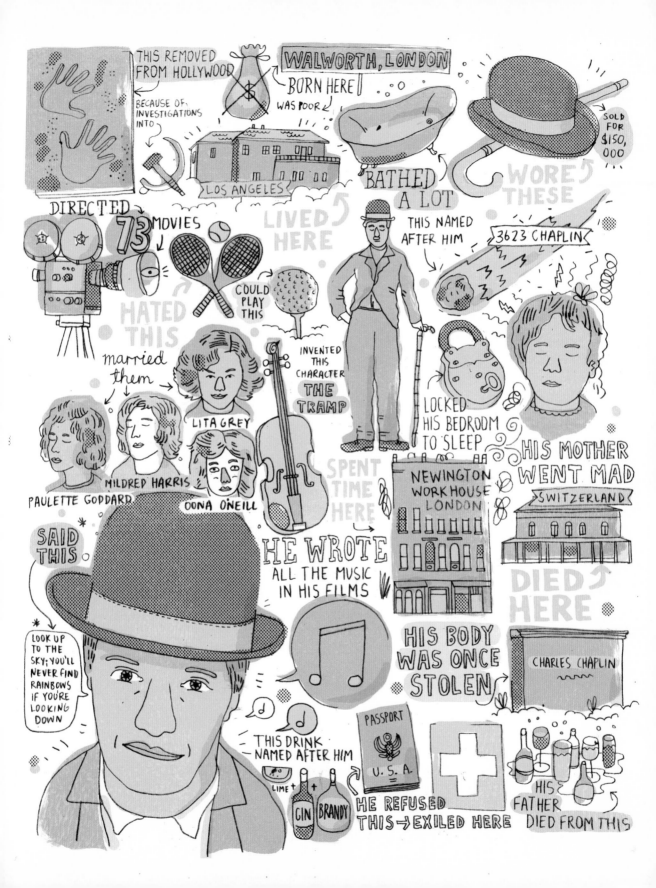

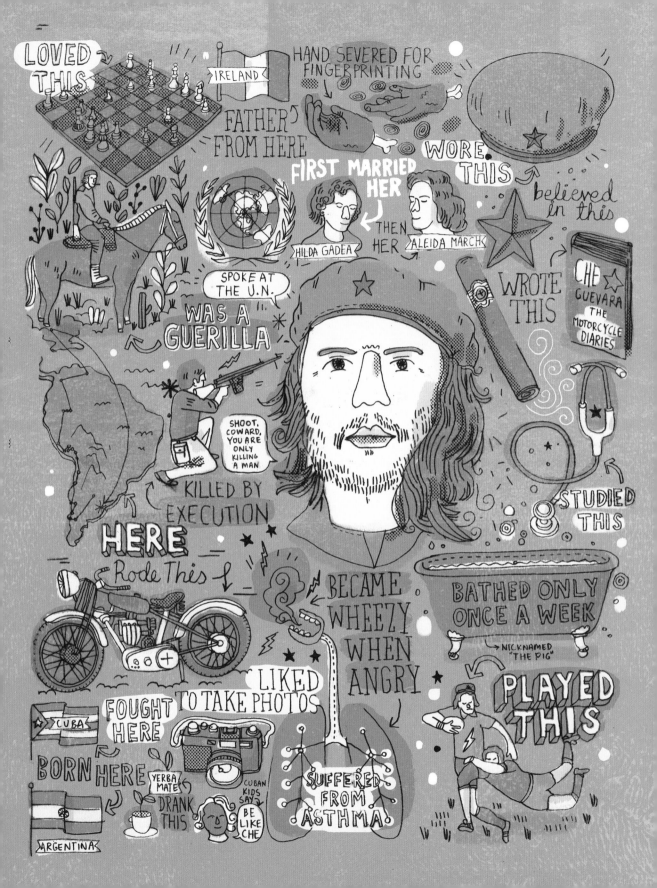

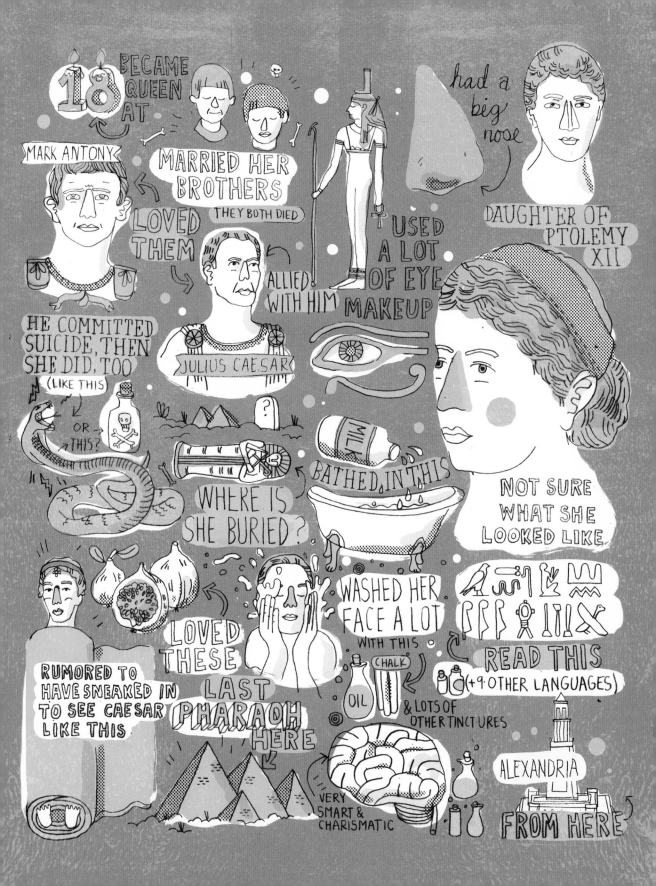

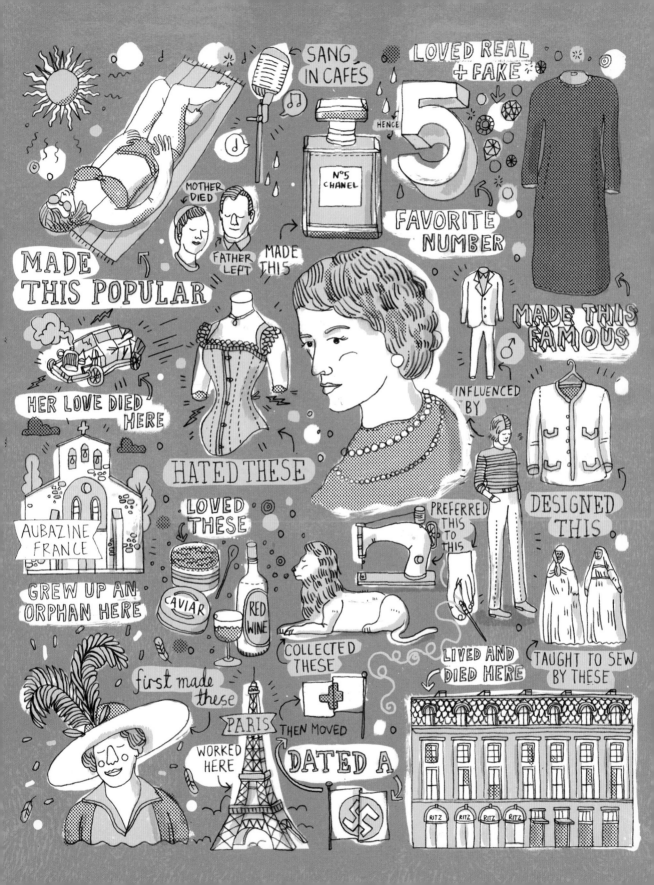

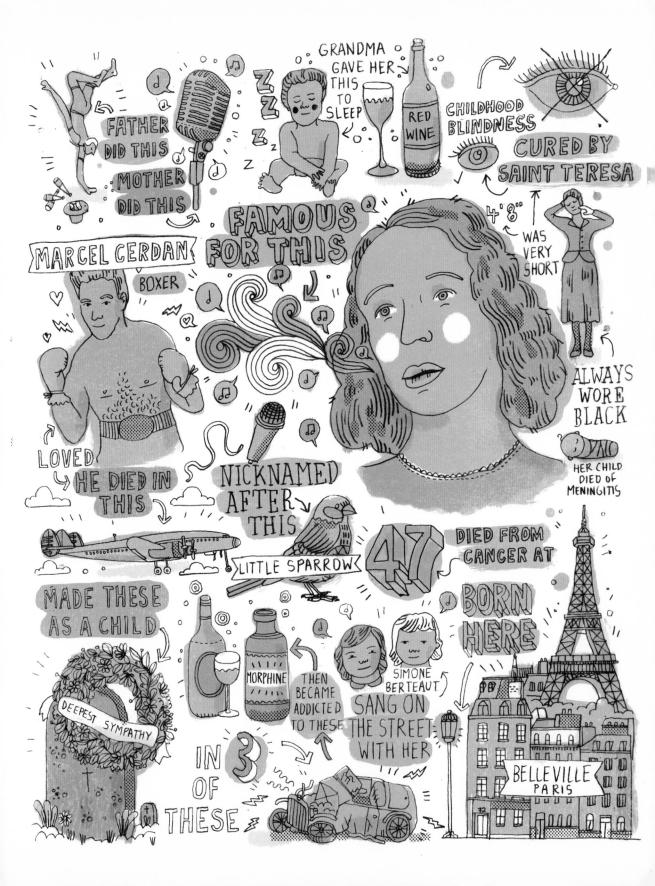

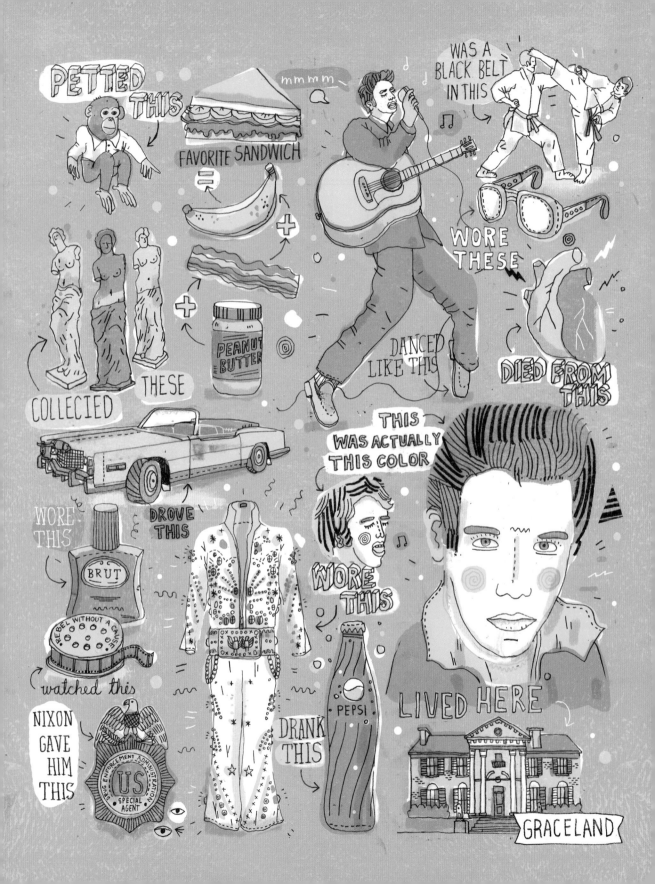

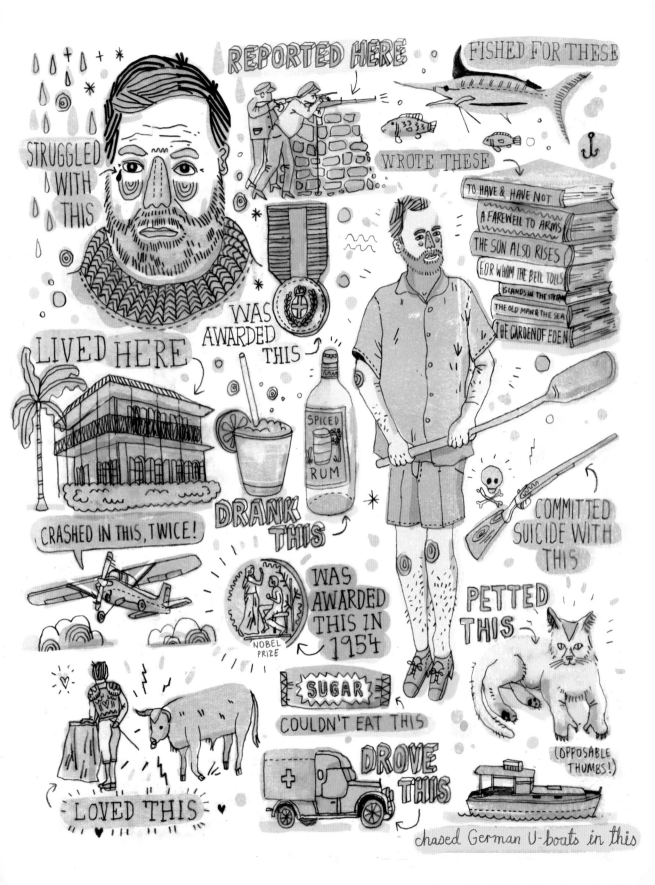

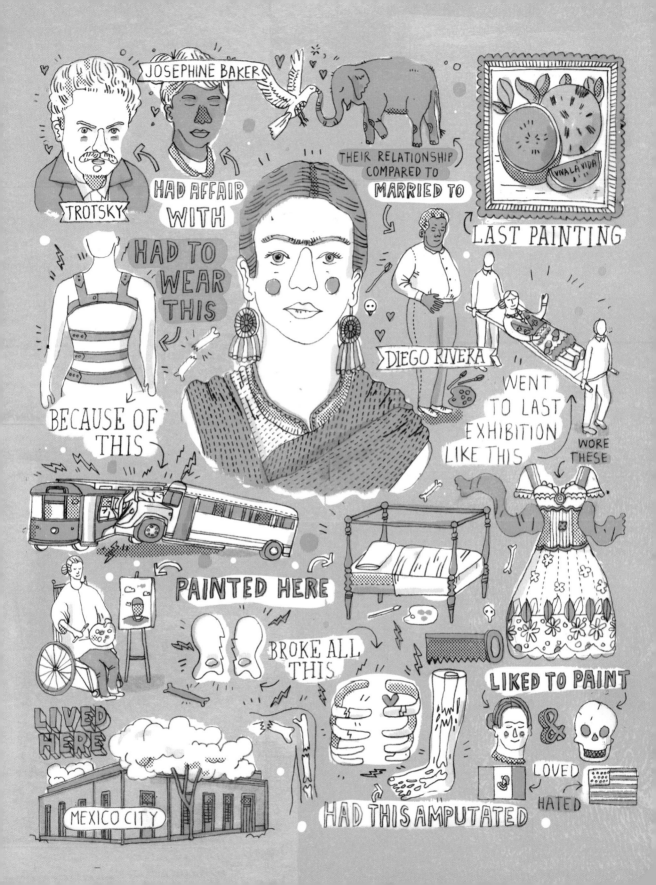

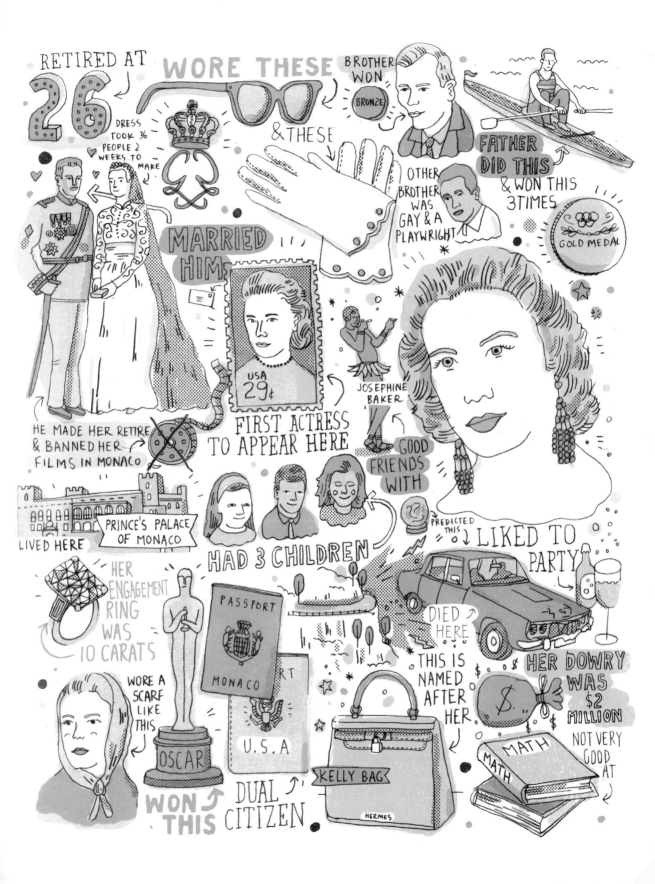

RETIRED AT 26

DRESS TOOK 36 PEOPLE 2 WEEKS TO MAKE

WORE THESE

BROTHER WON BRONZE

& THESE

FATHER DID THIS & WON THIS 3 TIMES

GOLD MEDAL

OTHER BROTHER WAS GAY & A PLAYWRIGHT

MARRIED HIM

USA 29¢

FIRST ACTRESS TO APPEAR HERE

JOSEPHINE BAKER

GOOD FRIENDS WITH

HE MADE HER RETIRE & BANNED HER FILMS IN MONACO

PRINCE'S PALACE OF MONACO

LIVED HERE

HAD 3 CHILDREN

PREDICTED THIS

LIKED TO PARTY

DIED HERE

HER ENGAGEMENT RING WAS 10 CARATS

PASSPORT

MONACO

U.S.A

WORE A SCARF LIKE THIS

OSCAR

WON THIS

DUAL CITIZEN

KELLY BAG

HERMES

THIS IS NAMED AFTER HER

HER DOWRY WAS $2 MILLION

NOT VERY GOOD AT

MATH
MATH

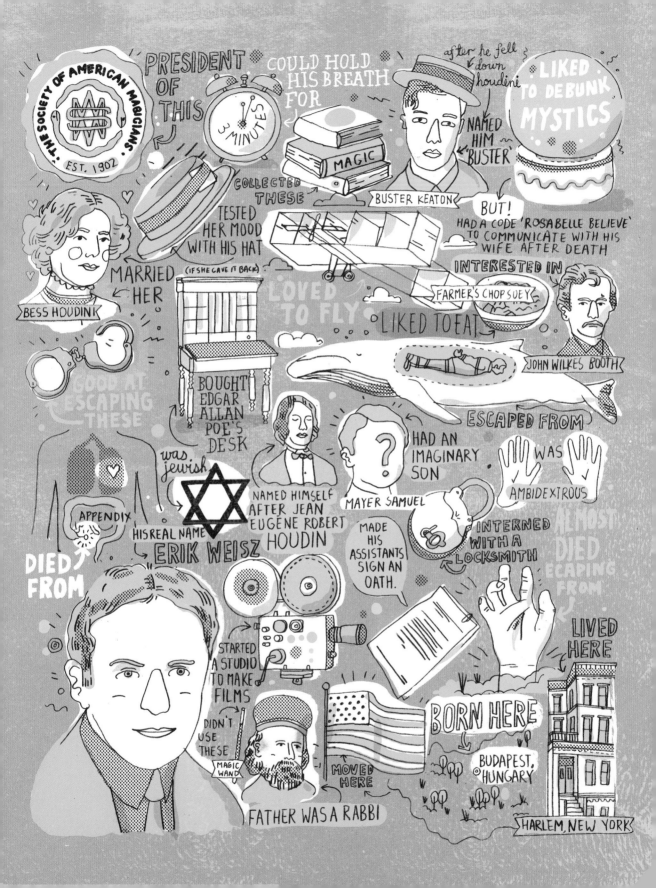

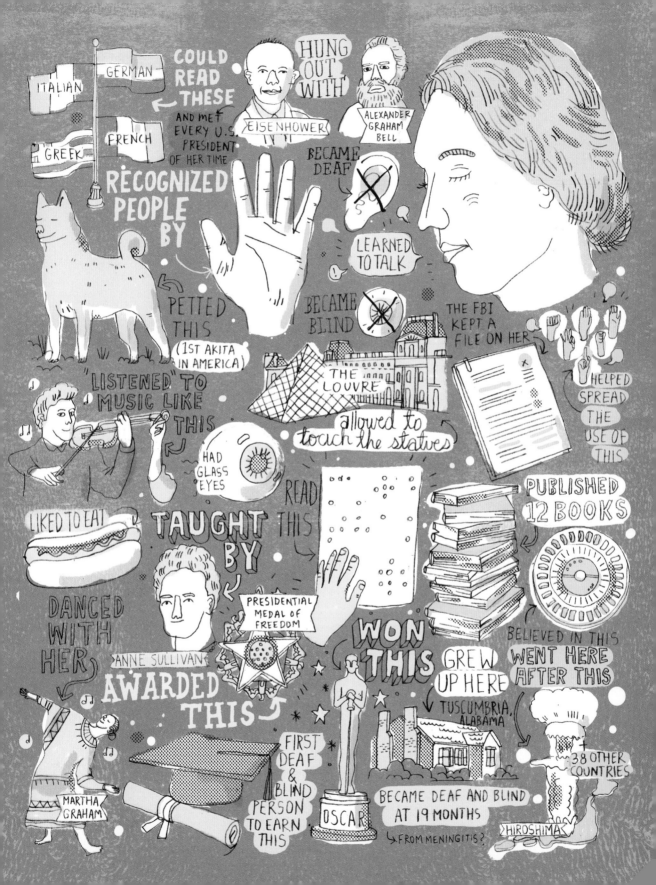

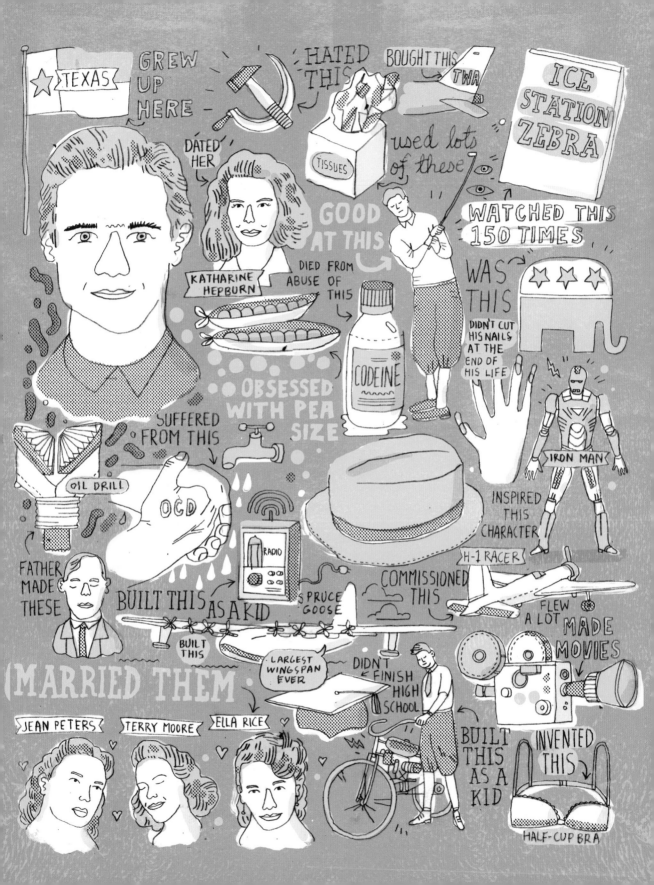

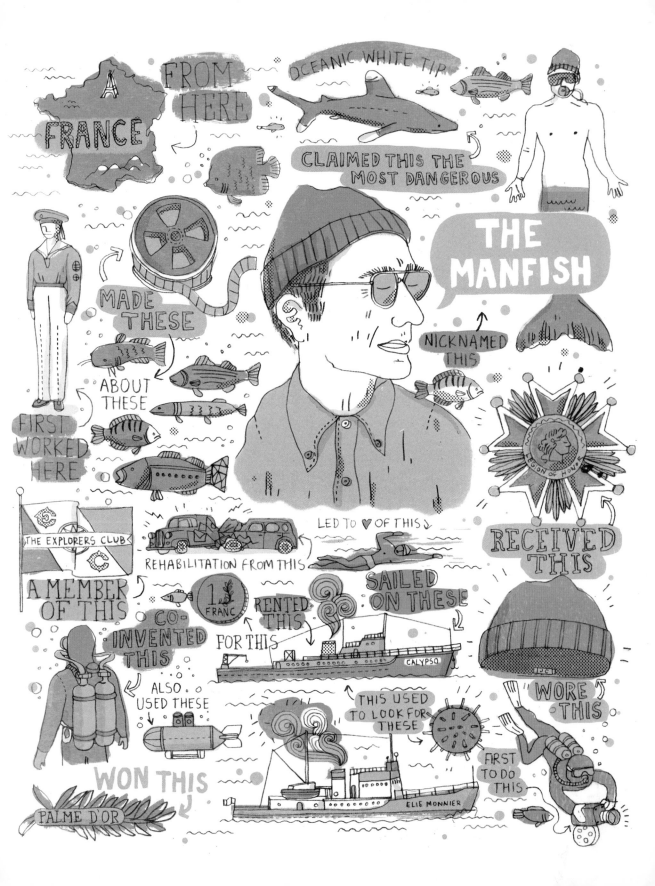

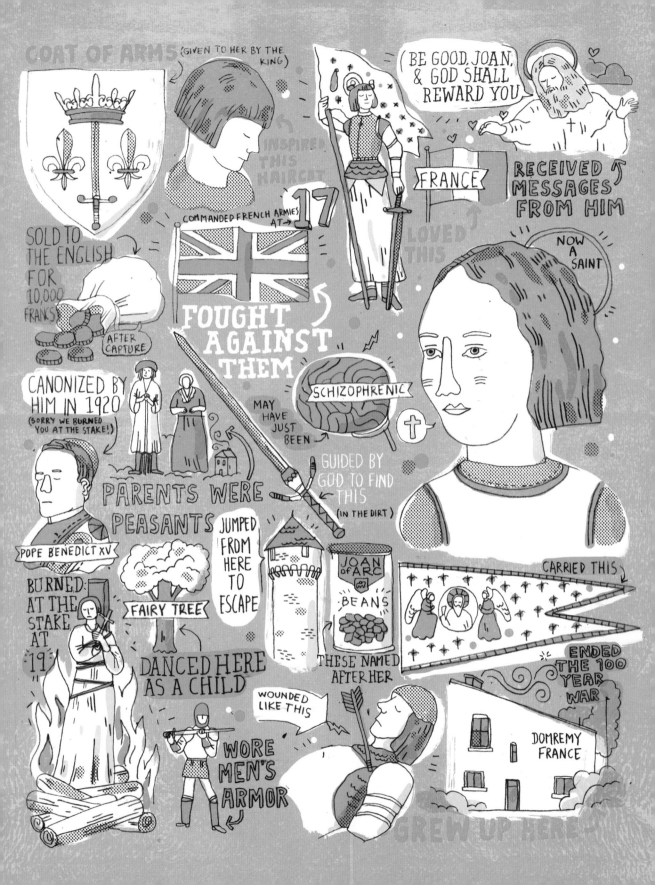

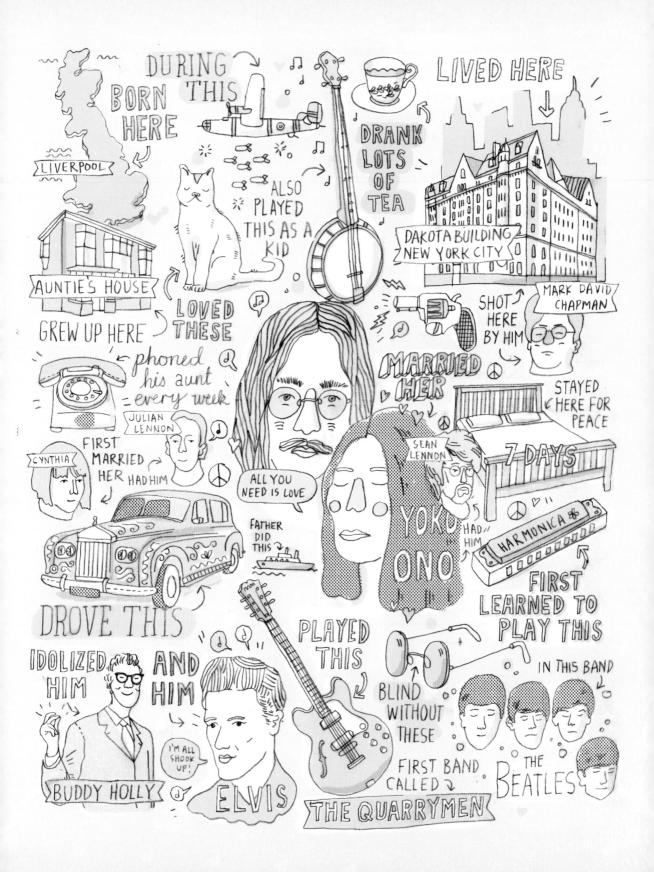

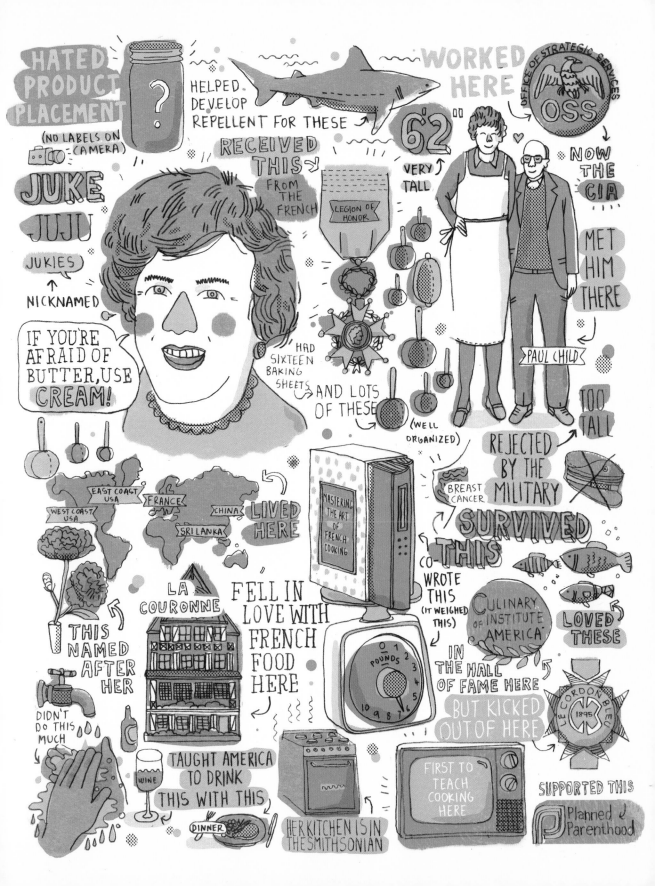

LEONARDO
DA VINCI

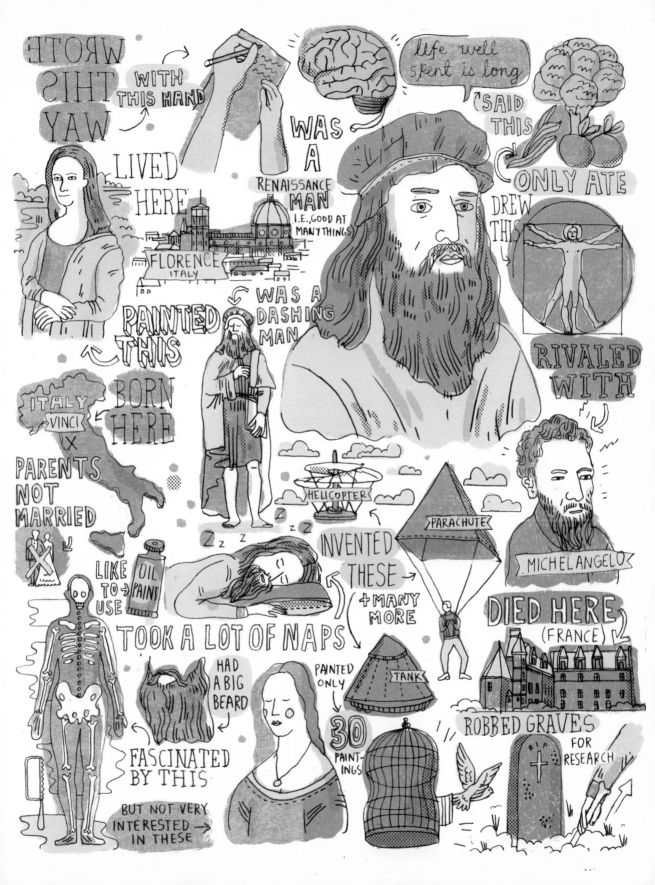

LEO
TOLSTOY

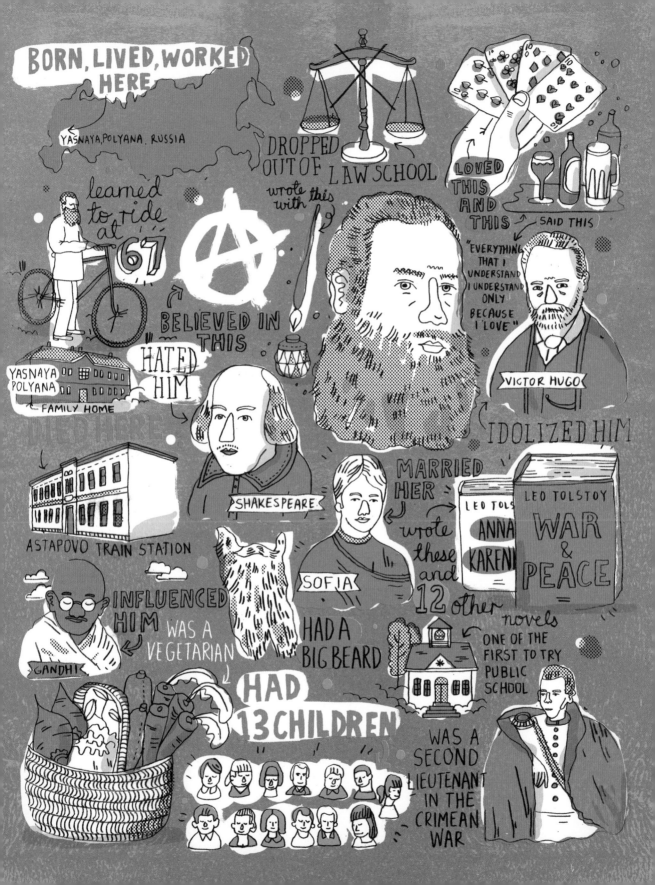

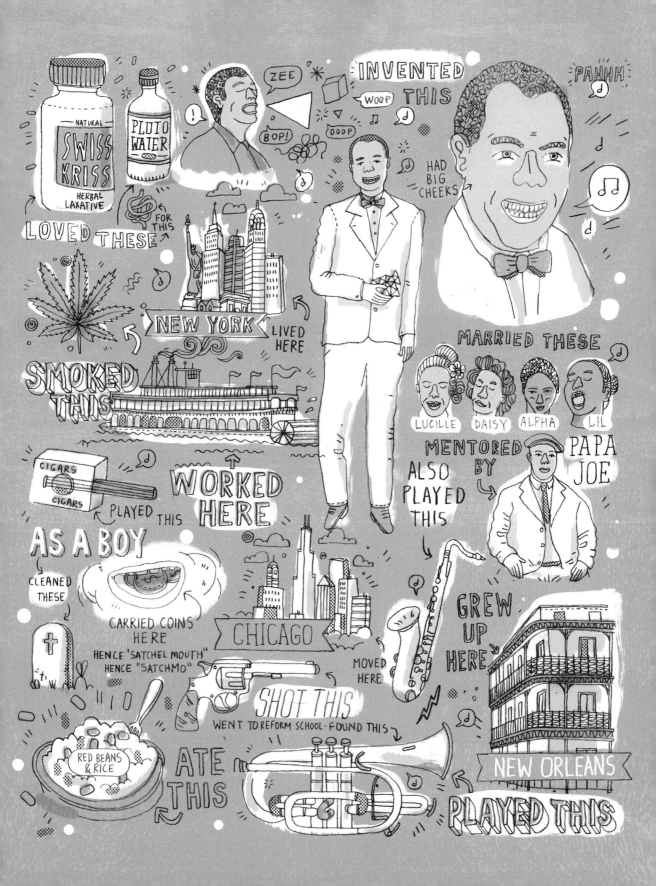

MADONNA

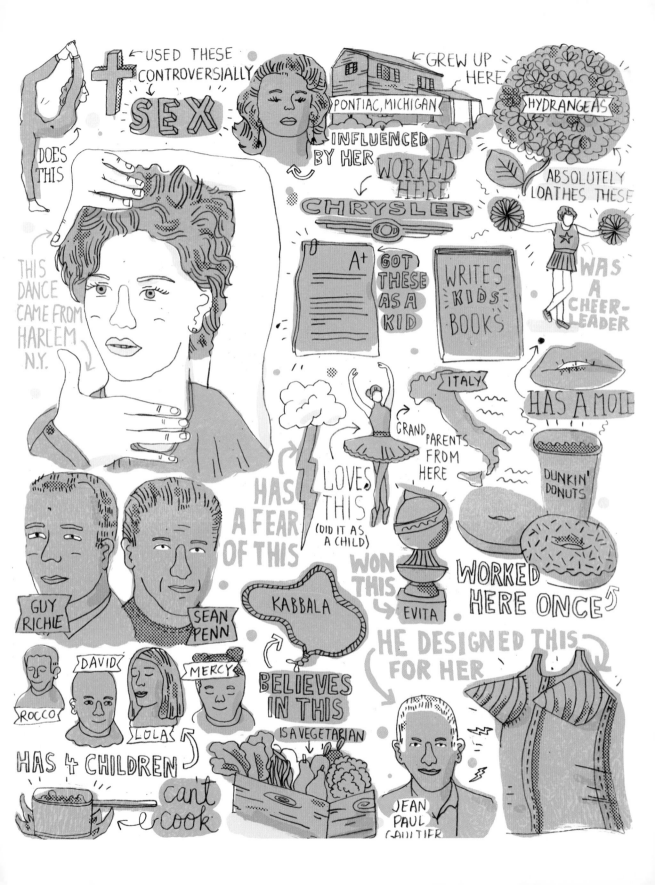

MAHATMA GANDHI

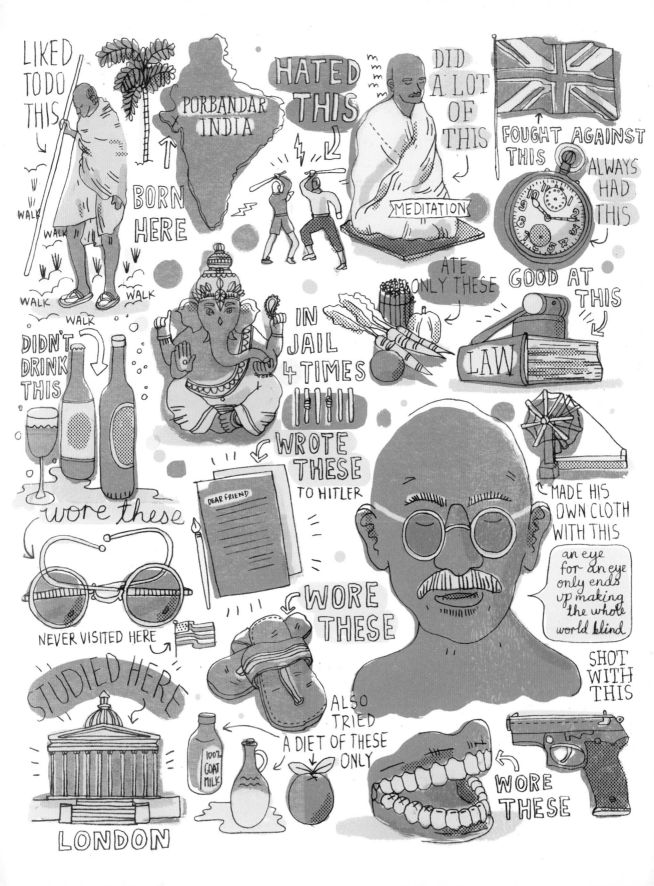

MARGARET THATCHER

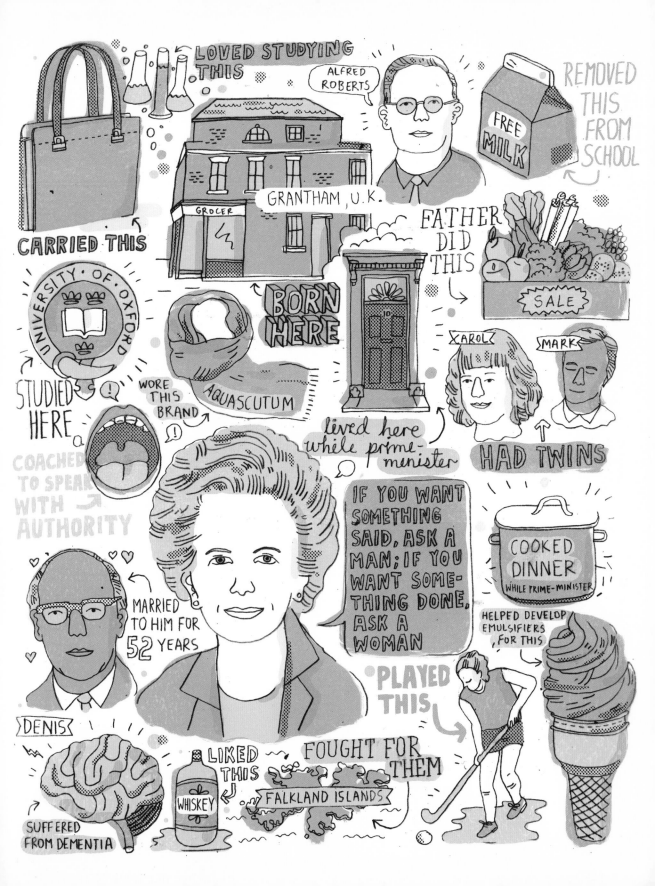

MARIE CURIE

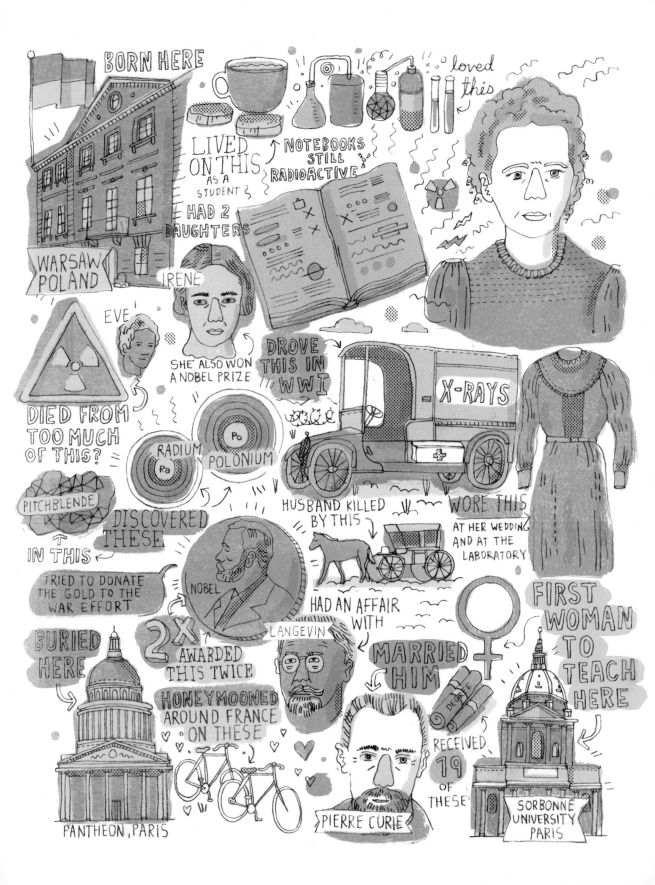

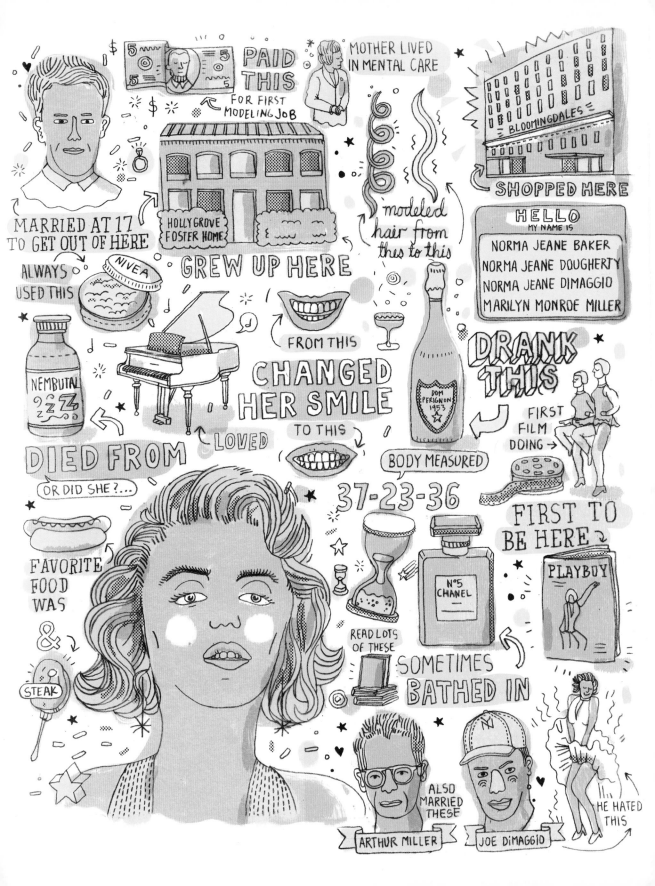

MARTIN
LUTHER
KING JR.

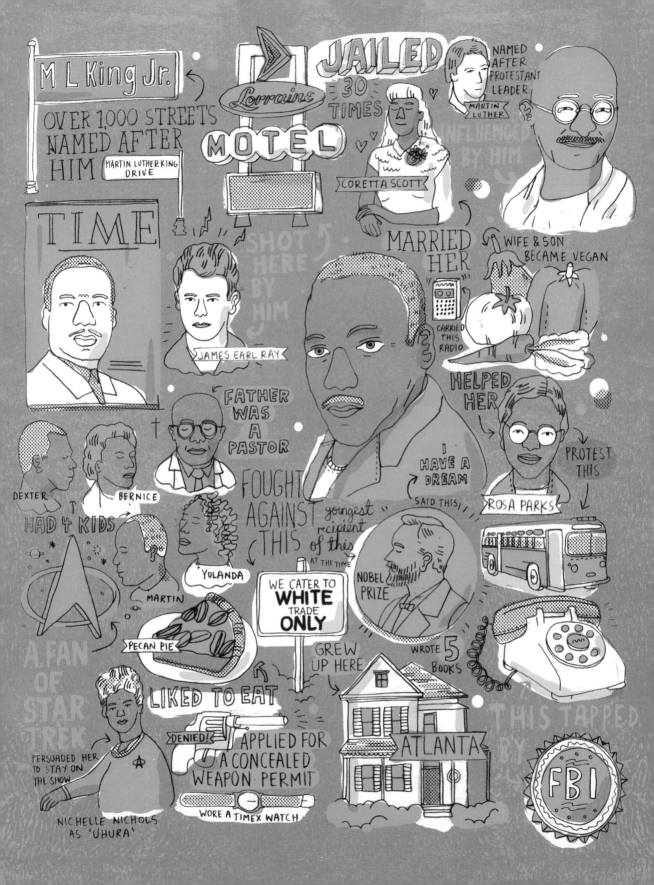

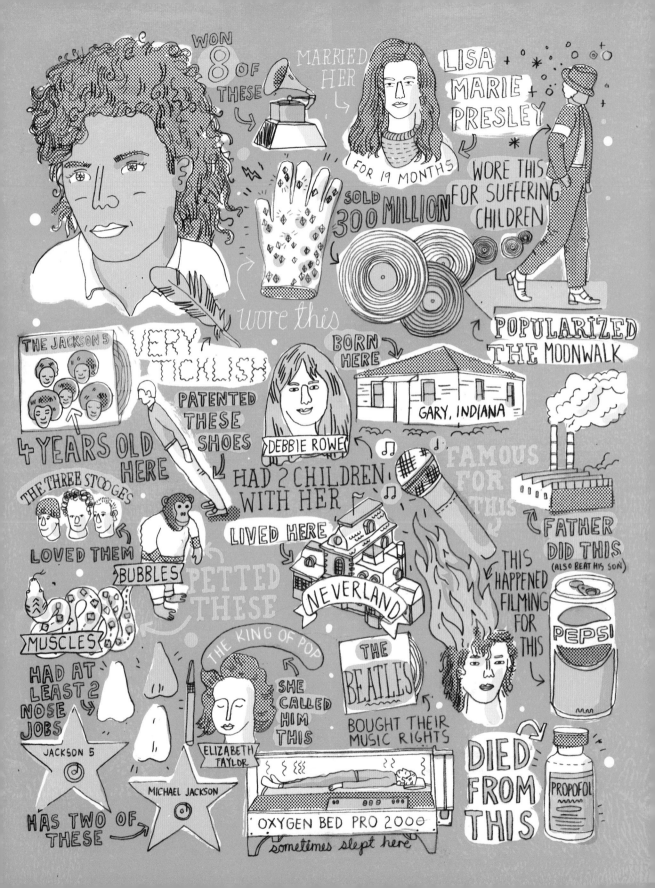

MUHAMMAD ALI

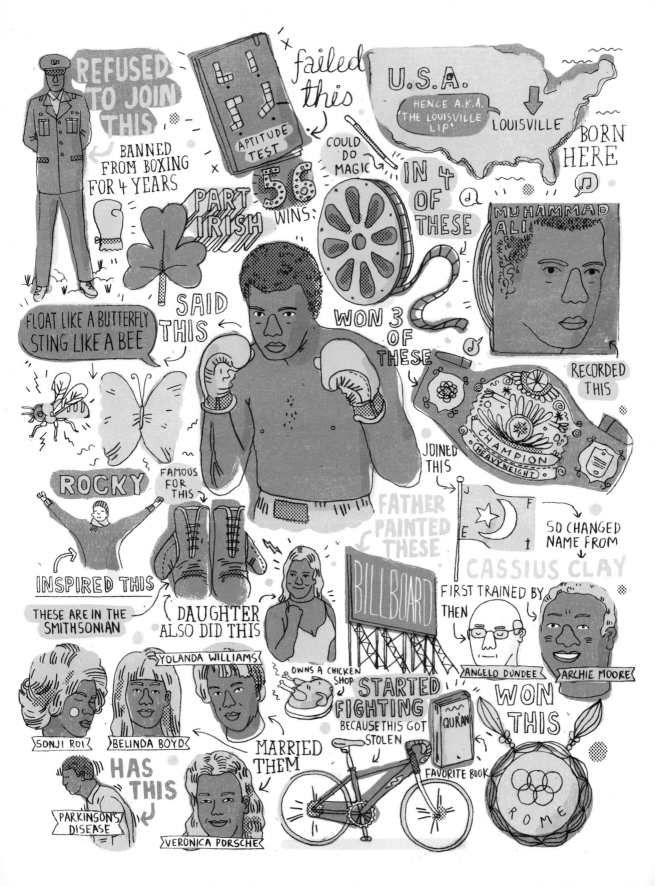

NAPOLEON
BONAPARTE

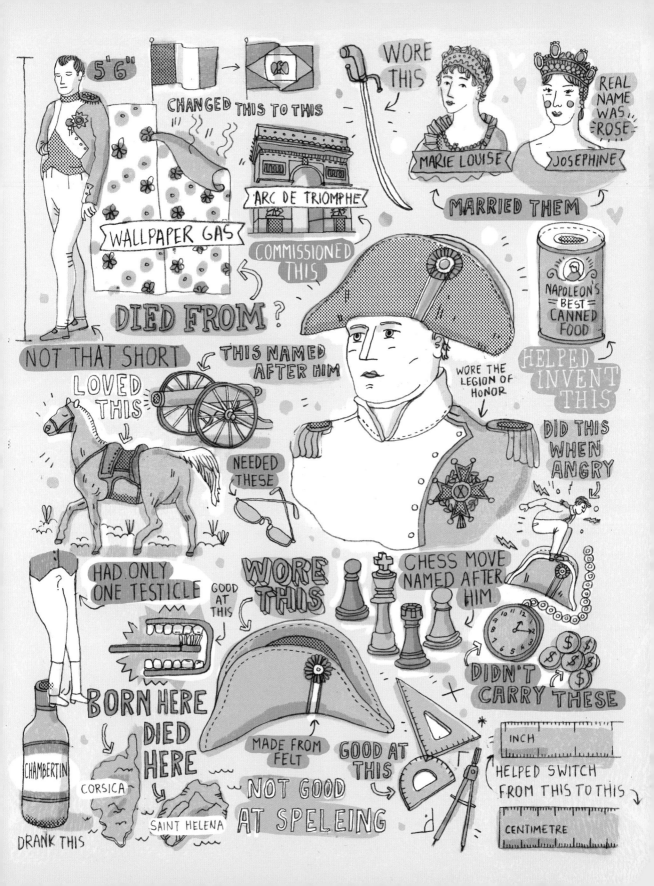

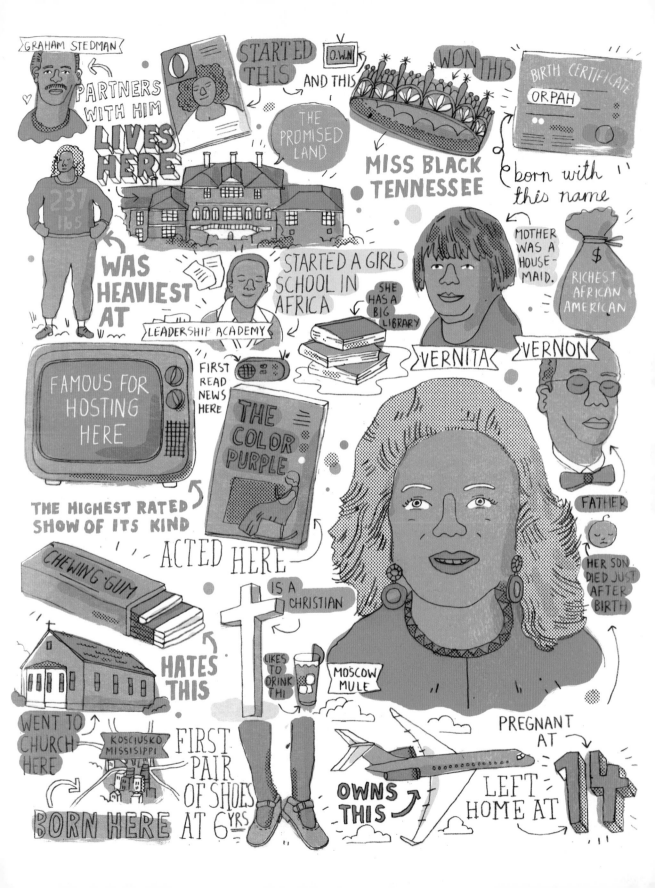

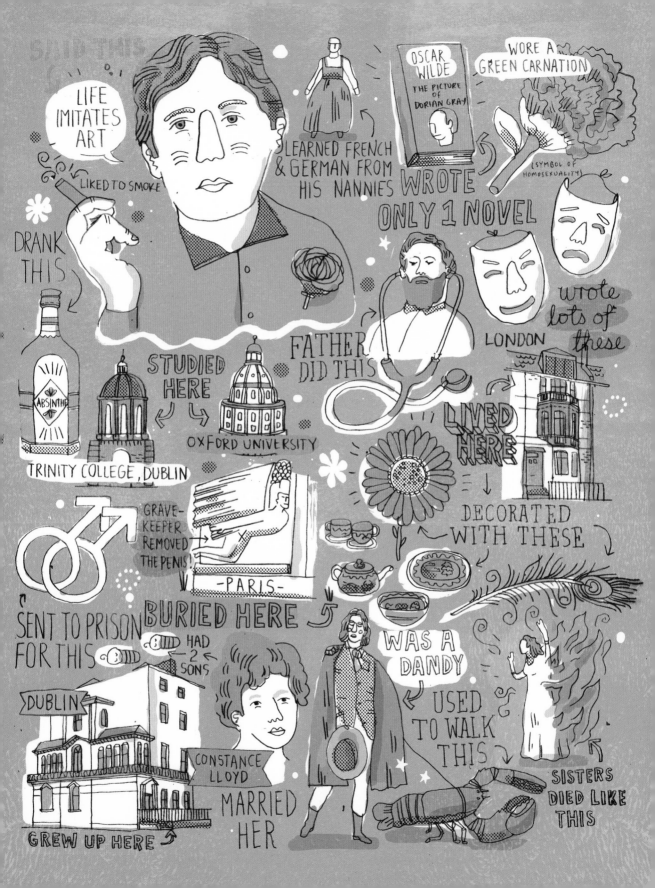

princess
DIANA

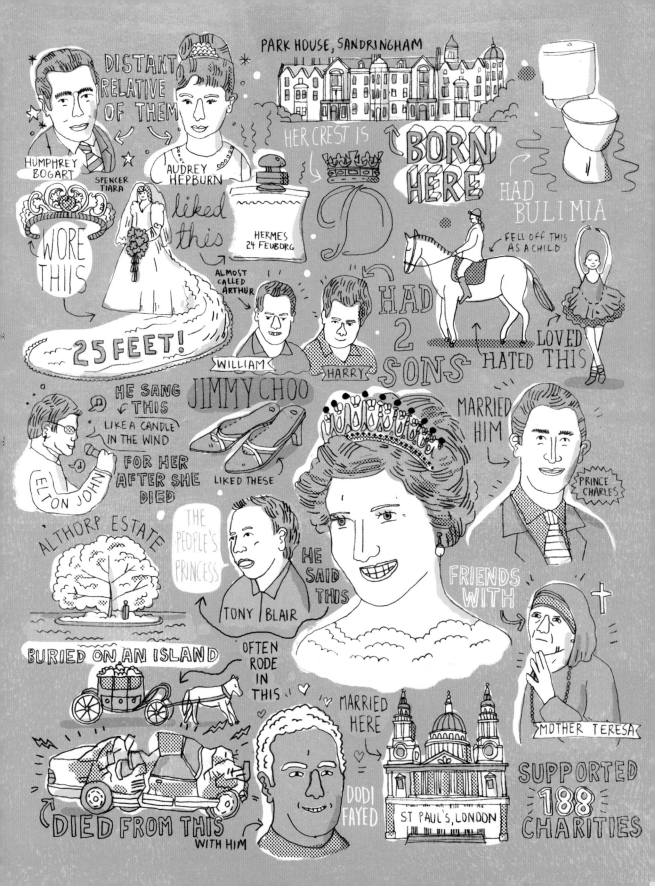

QUEEN
Elizabeth I

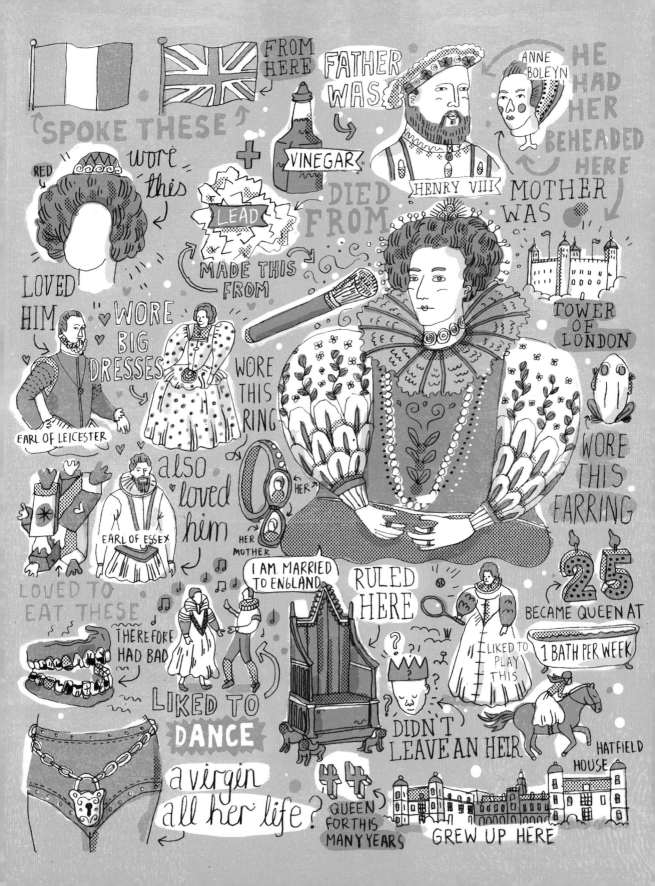

SALVADOR DALÍ

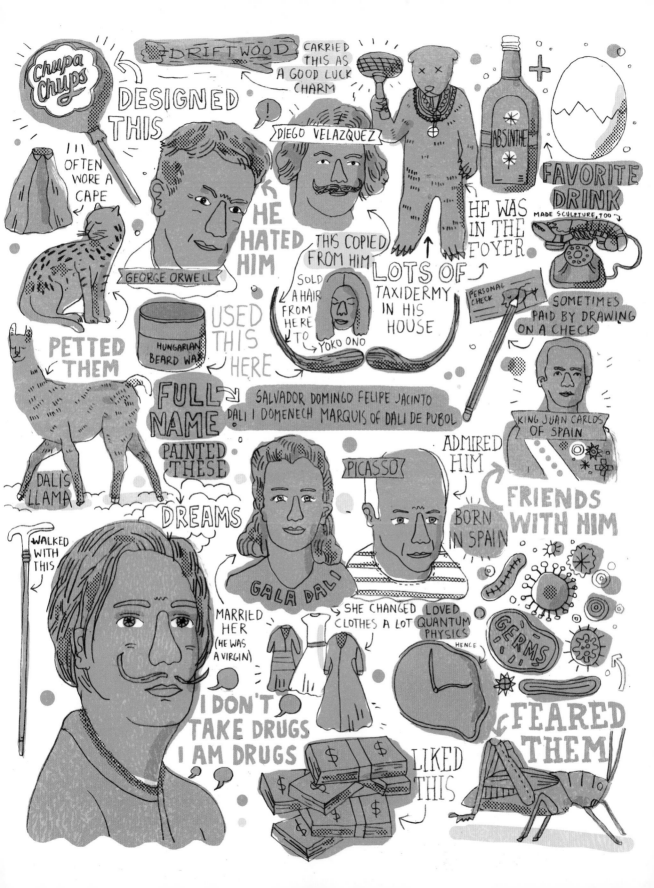

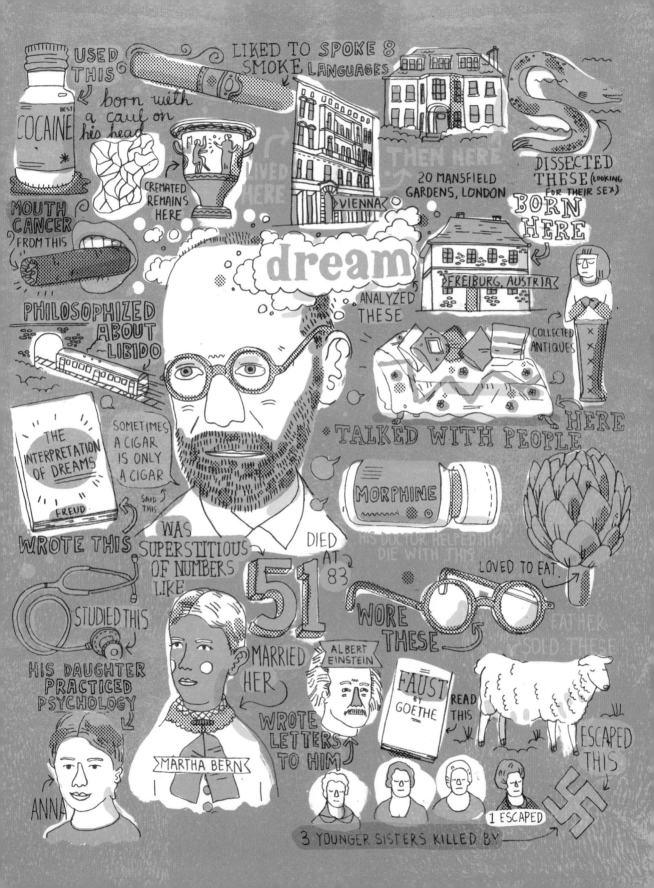

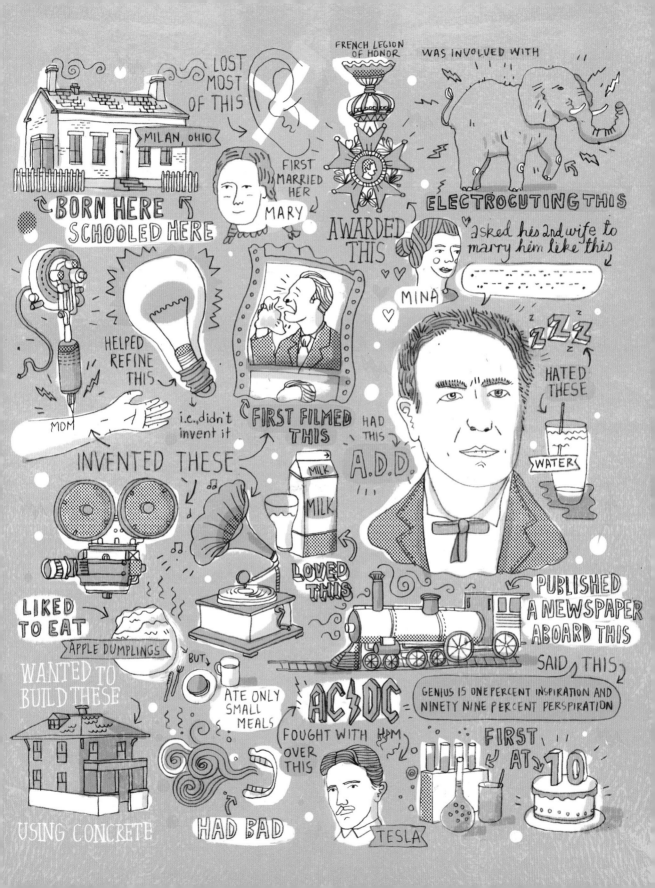

Vincent Van Gogh

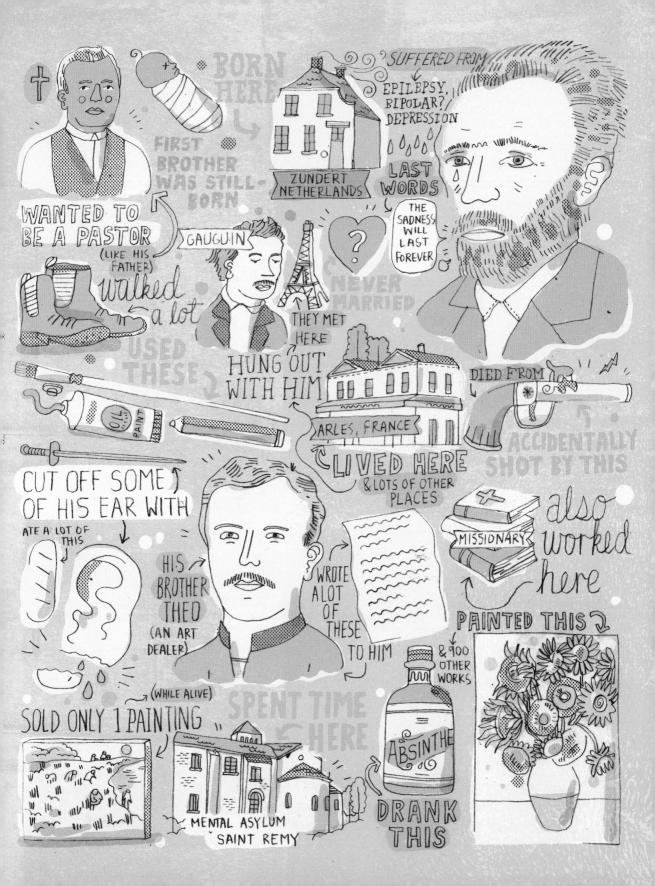

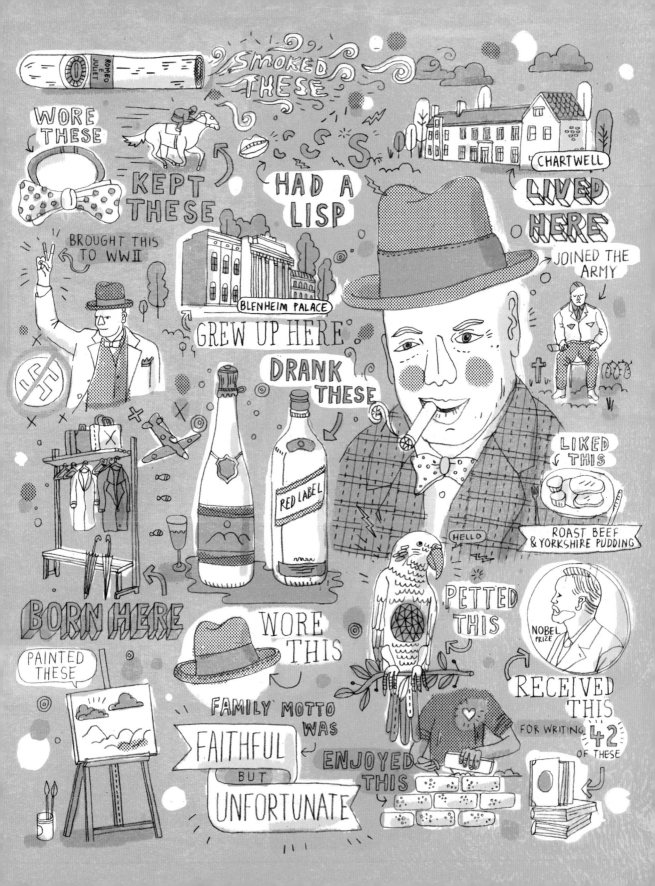

WOLFGANG AMADEUS MOZART

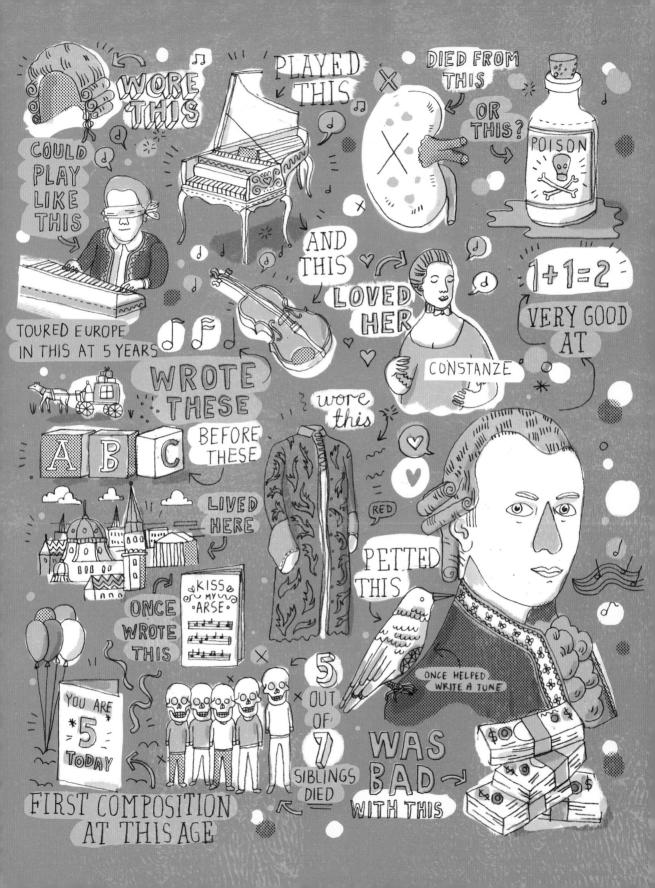

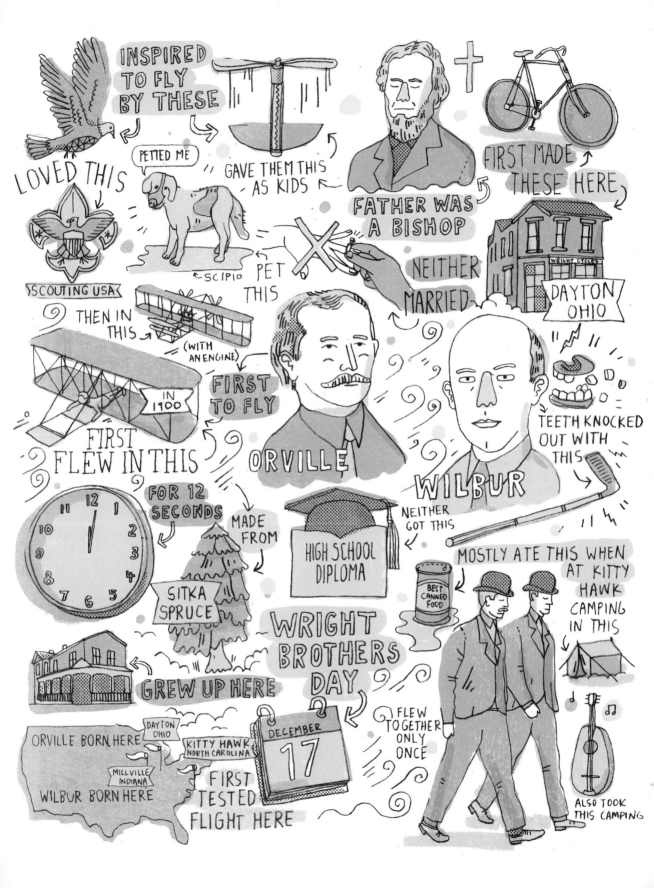

ABOUT THE AUTHOR

JAMES GULLIVER HANCOCK

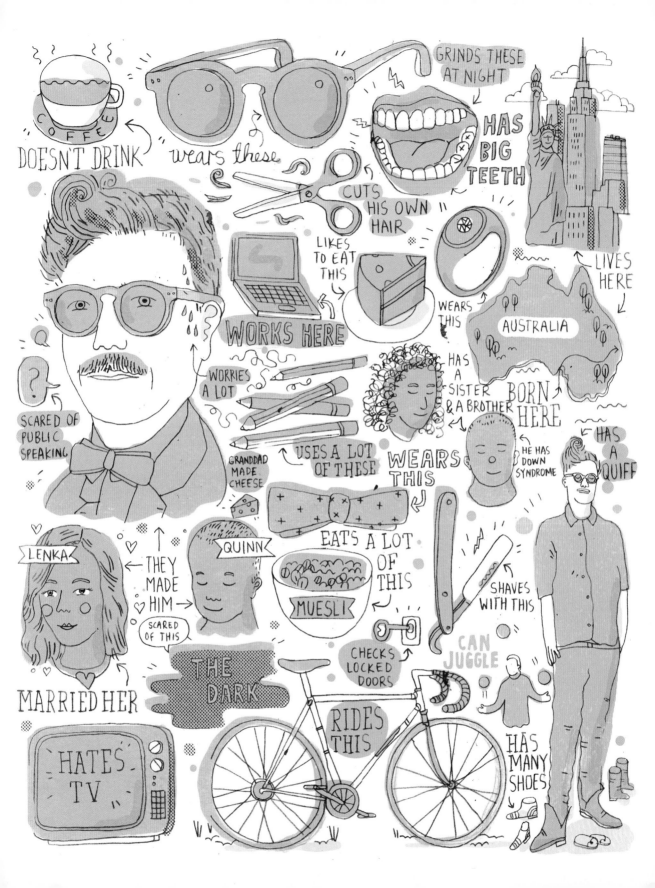

Thanks to my family, Lenka Kripac and Quinn Gulliver Hancock, for their patience with the hours and hours I put in at the studio to finish this project; to all those people who brilliantly helped me research and check the facts: Sarah Winshall, Christopher Thomas, Anton Gill, Susan Dietrich, Frances Haggett, Mollie Hancock, and Alicia Desantis; and also to the amazing team at Chronicle Books: Bridget Watson Payne, Caitlin Kirkpatrick, Kristen Hewitt, Erin Thacker, Lia Brown, Becca Boe, Peter Perez, and Diane Levinson.